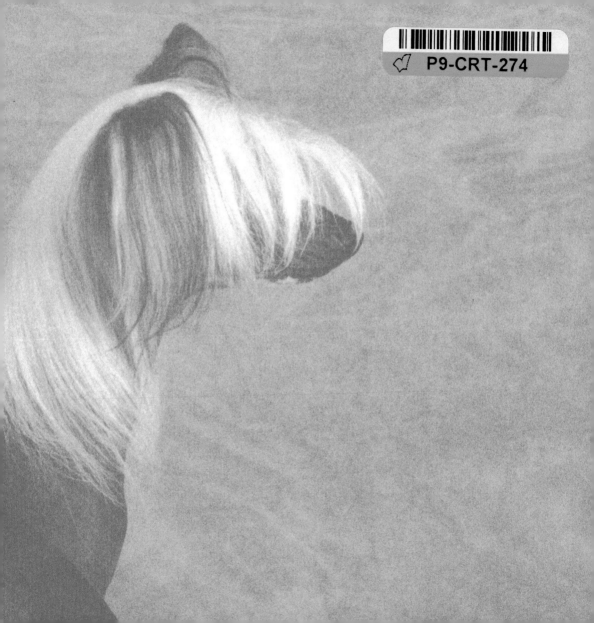

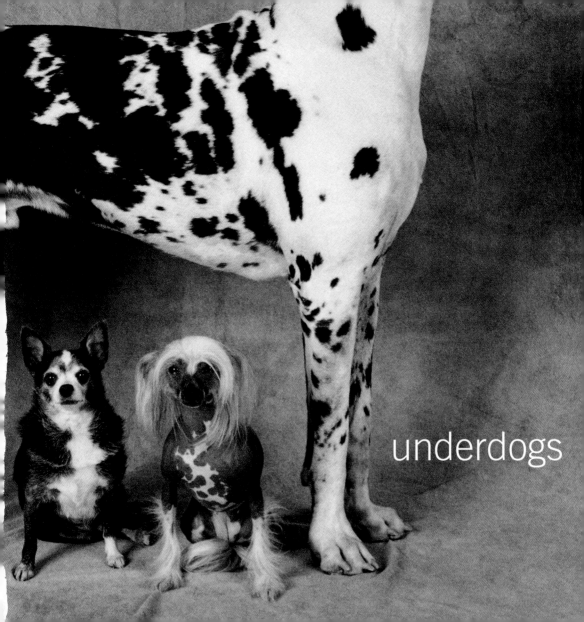

underdogs

under

BEAUTY IS MORE THAN FUR DEEP

dogs

Jim Dratfield

Clarkson Potter/Publishers
New York

Published by Clarkson Potter / Publishers, New York, New York.
Member of the Crown Publishing Group.
Random House, Inc. New York, Toronto, London, Sydney, Auckland
www.randomhouse.com

CLARKSON N. POTTER is a trademark, and POTTER and colophon
are registered trademarks of Random House, Inc.

Printed in Singapore

Design by Jane Treuhaft

Library of Congress Cataloging-in-Publication Data
Dratfield, Jim.
Underdogs: beauty is more than fur deep/Jim Dratfield—1st ed.
p. cm.
1. Dogs—Pictorial works. 2. Photography of dogs. I. Title.
SF430 .D74 2002
636.7'0022'2—dc21 2001035985

ISBN 0-609-60872-X
10 9 8 7 6 5 4 3 2
First Edition

I cling to my imperfections as
the very essence of my being.

ANATOLE FRANCE

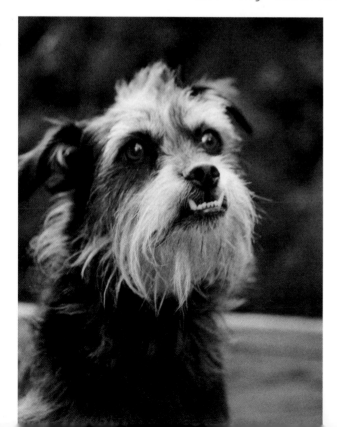

If Americans love anything, it's the underdog.

We're a nation of underdogs, a society that celebrates the triumph of personality over heritage. We believe that if you have character, determination, and intelligence, you can become anything. So we root for the football team that defies all odds to upset the defending champion, the small start-up business that competes with a corporate monolith, the poor rural kid who walks miles to school each day and eventually becomes president of the United States.

But we sometimes overlook those underdogs who gave the word its meaning—the under*dogs*. (A word we invented here in America, by the way.) We're more often overcome with images of beautiful little Labrador retrievers, all puppy-eyed and big-footed and tripping over themselves with enthusiasm. Or of smart Jack Russells, or heroic purebred German shepherds, or movie-star Dalmatians.

But as I go about my business as a photographer of pets, I often find something remarkable: the dogs of indeterminate, impure, or unfashionable pedigree can be the most charming companions of all. So this book is a celebration of those underdogs—and a reminder of who we are. Some of the dogs pictured in this book are, in fact, purebreds; but their breeds are not the most celebrated, trendy ones. Many other dogs in here are mixed breeds—as are more than half the dogs in this country. But all of them are dogs of personality, of intelligence, and sometimes of humor. All of them are loved; in turn, all of them love.

And love has no pedigree.

My life has no purpose,
no direction, no aim, no meaning,
and yet I'm happy.
I can't figure it out.
What am I doing right?

CHARLES M. SCHULZ

8

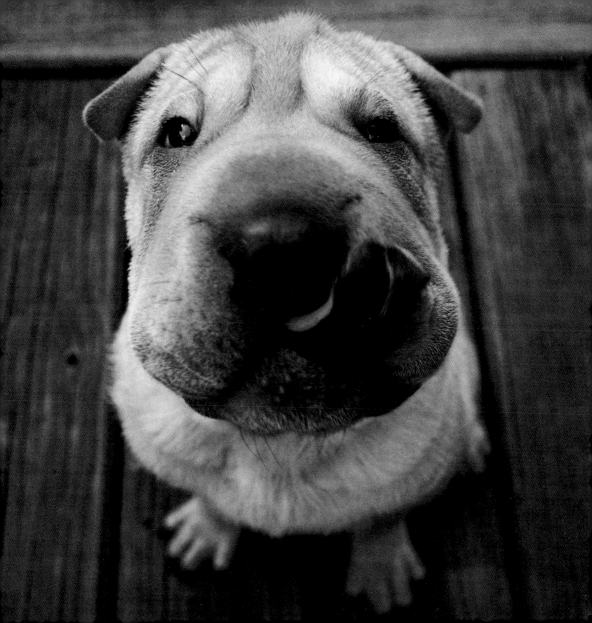

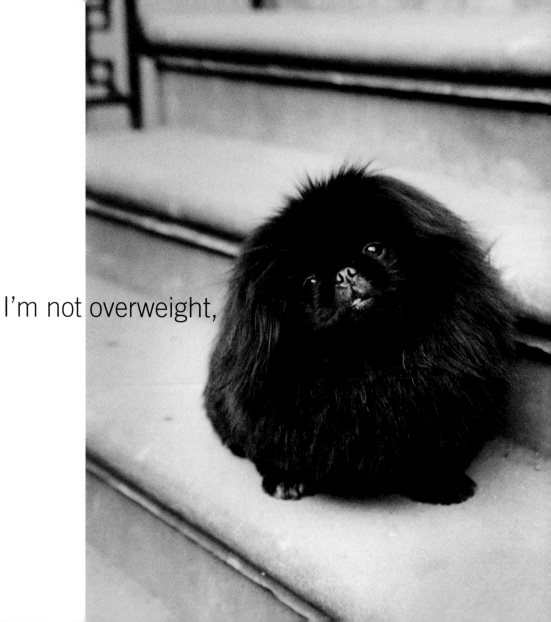

I'm not overweight,

I'm just nine inches too short.

SHELLY WINTERS

If you are possessed by an idea,
you find it expressed everywhere,
you even smell it.

THOMAS MANN

1
2

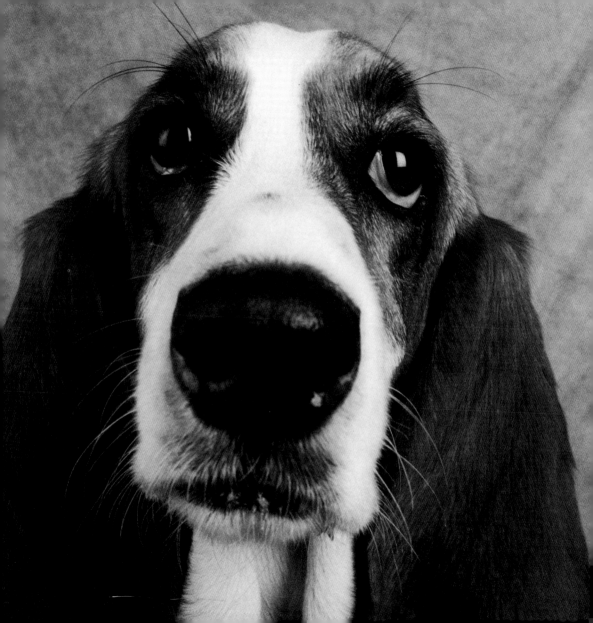

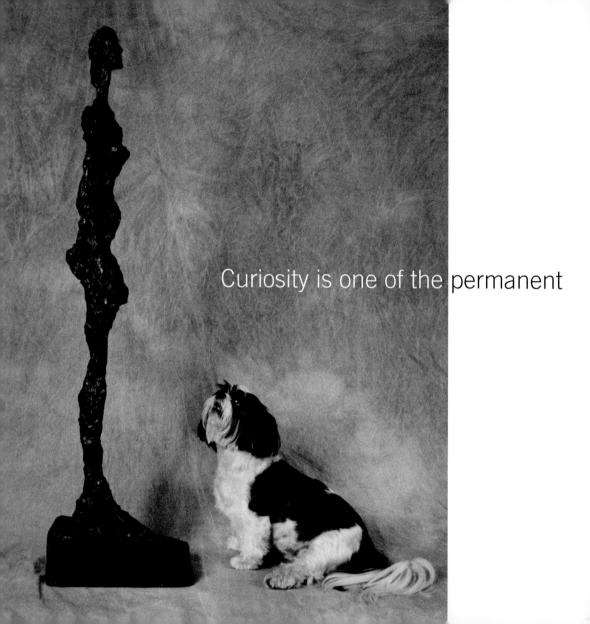

Curiosity is one of the permanent

and certain characteristics of a vigorous mind.

SAMUEL JOHNSON

When we lose the right to be different,
we lose the privilege to be free.

CHARLES EVANS HUGHES

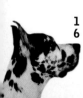

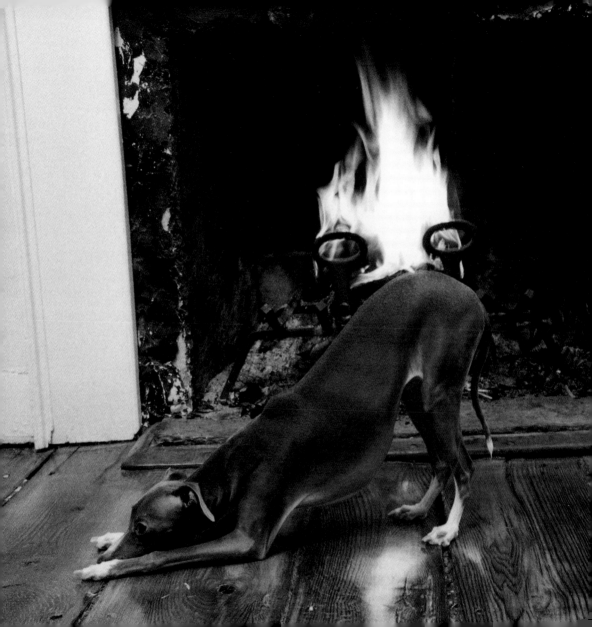

Perfection

is out of the question.

ANNE ARCHER

Conformity is the jailer of freedom

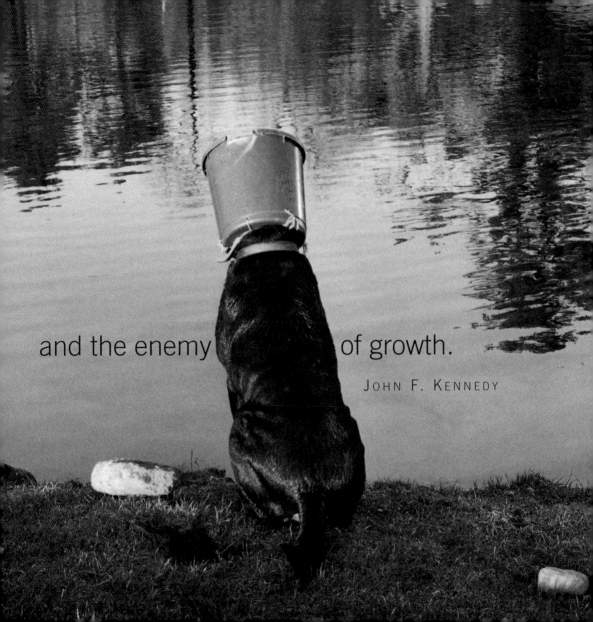

and the enemy of growth.

JOHN F. KENNEDY

All things are possible to one who believes.

St. Bernard of Clairvaux

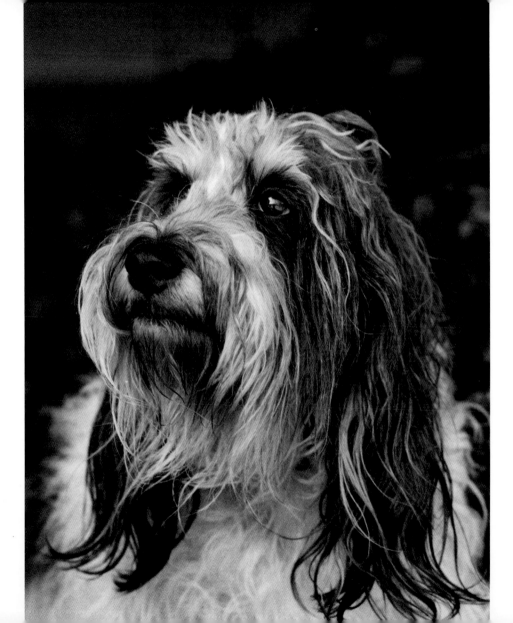

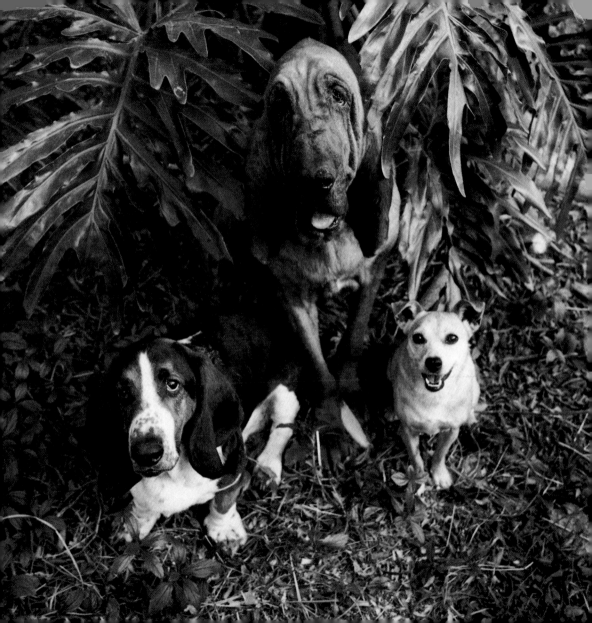

When I hear tell of the character and the loyalty and devotion of dogs, I remain unmoved. All of my dogs have been scamps and thieves and troublemakers, and I've adored them all.

HELEN HAYES

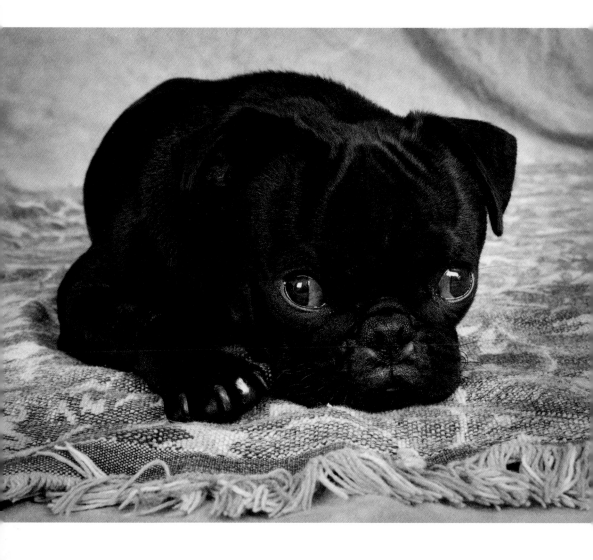

Boredom. The desire for desires.

LEO TOLSTOY

The only thing I regret about my past is the length of it. If I had to live my life again, I'd make the same mistakes, only sooner.

<div align="right">TALLULAH BANKHEAD</div>

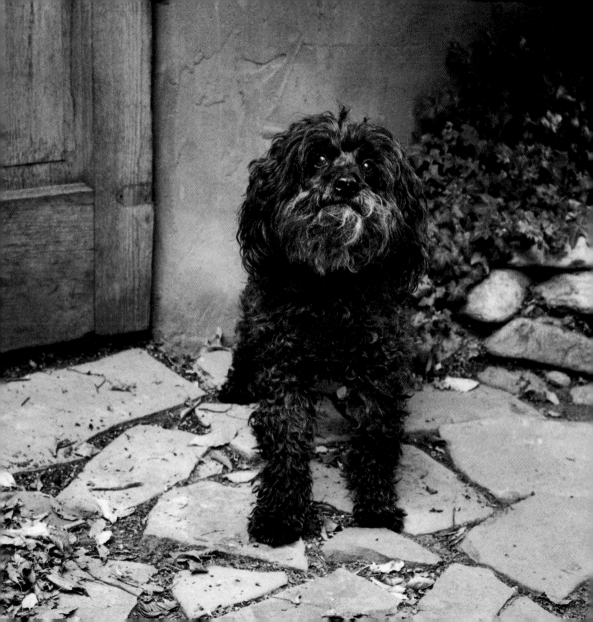

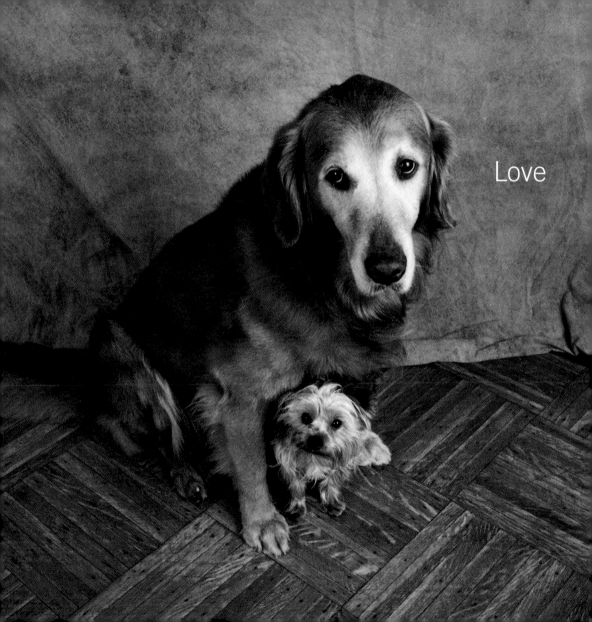

Love

is the greatest beautifier in the universe.

MAY CHRISTIE

Lead me not into temptation;

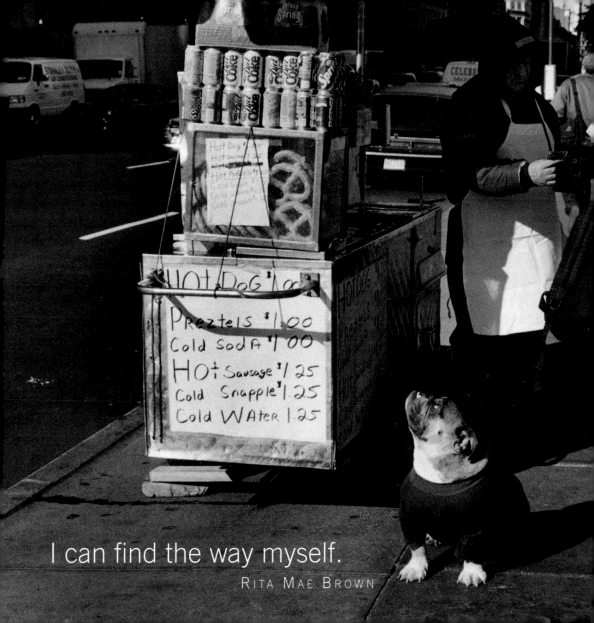

Preztels $1.00
Cold sodA $1.00
HOt Sausage $1.25
Cold Snapple $1.25
Cold WAter 1.25

HOt DoG $

I can find the way myself.

RITA MAE BROWN

The real voyage of discovery
consists not in seeking new landscapes
but in having new eyes.

MARCEL PROUST

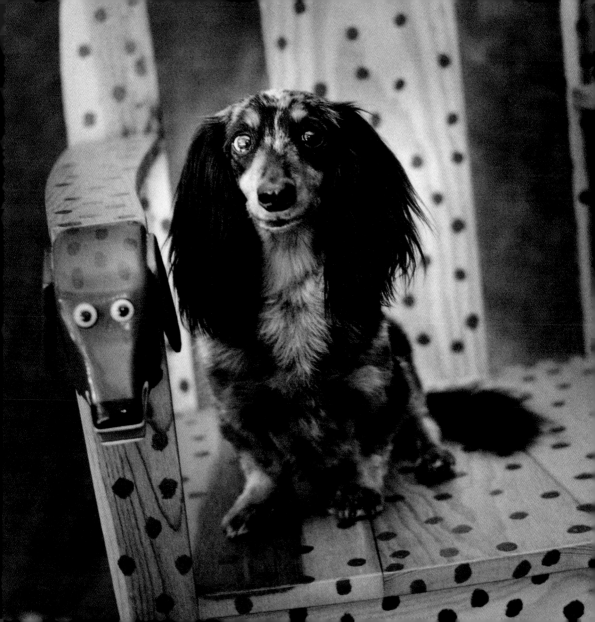

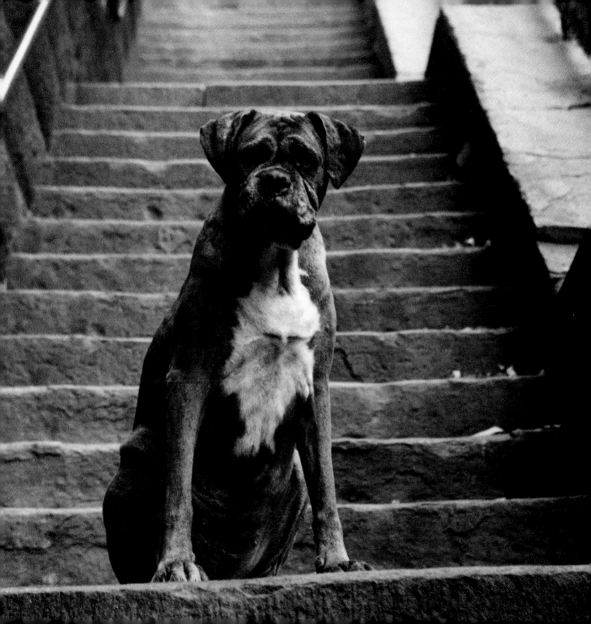

I never think of the future.
It comes soon enough.

ALBERT EINSTEIN

Blessed are the meek:

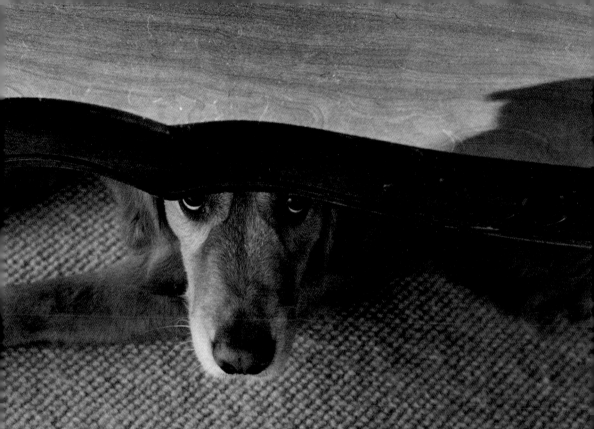

for they shall inherit the earth.

MATTHEW 5:5

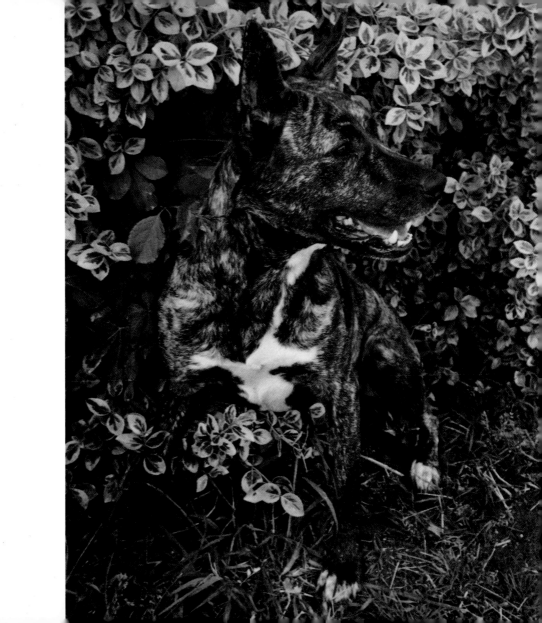

Appearances often are deceiving.

AESOP

1

Nature made him and then

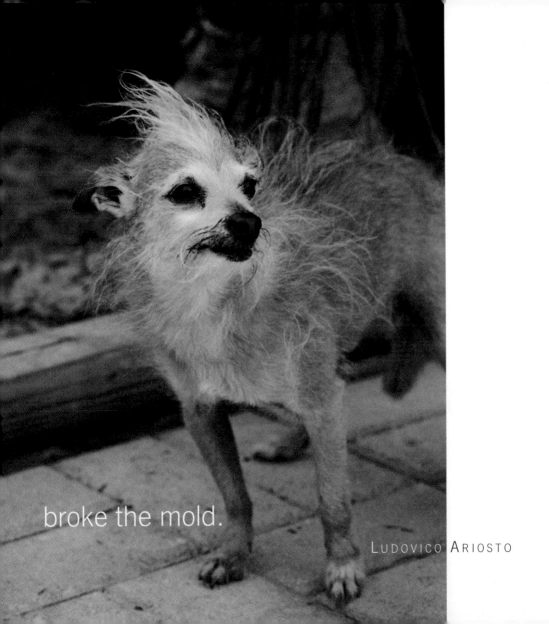

broke the mold.

L UDOVICO A RIOSTO

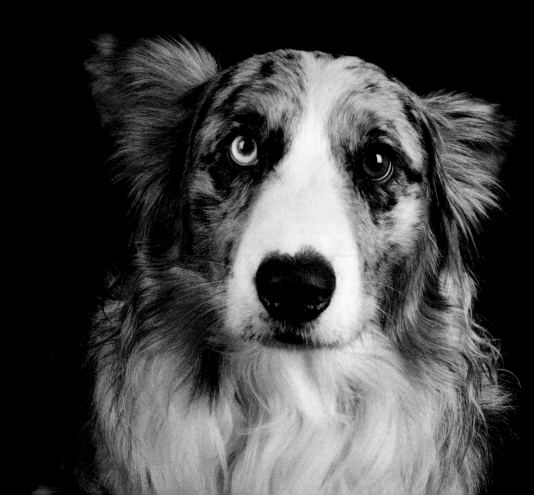

Eyes so transparent that

rough them one sees the soul.

THÉOPHILE GAUTIER

Look for the ridiculous in everything

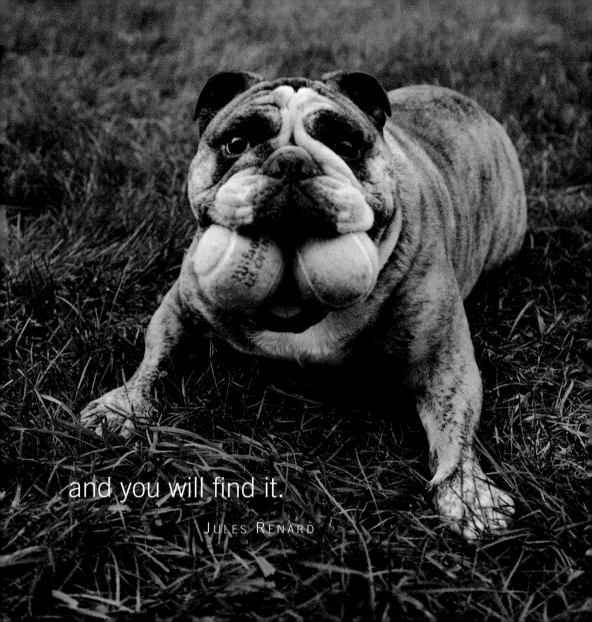

and you will find it.

JULES RENARD

Have no friends not

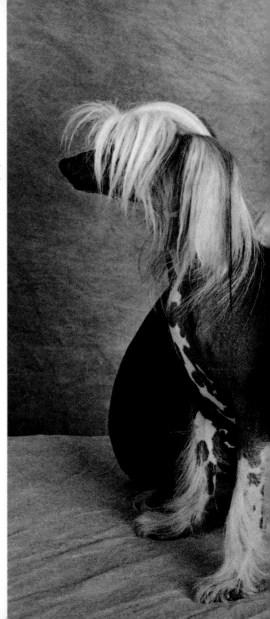

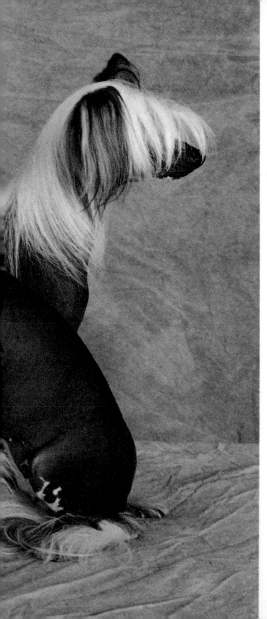

equal to yourself.

CONFUCIUS

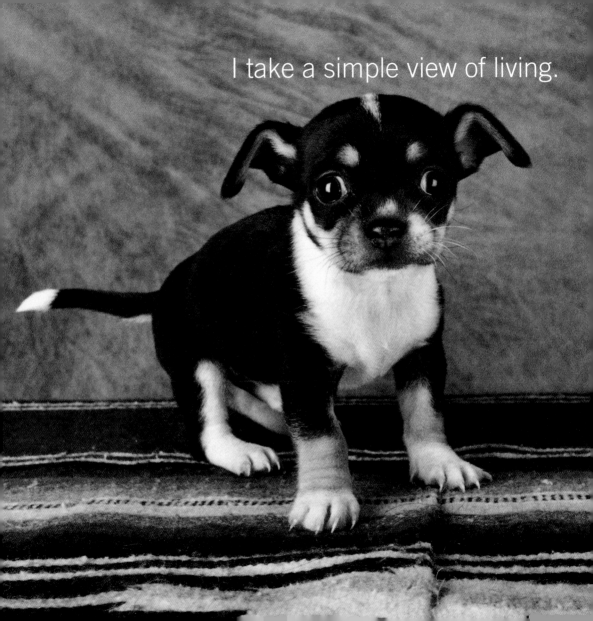
I take a simple view of living.

It is to keep your eyes open
and get on with it.

SIR LAURENCE OLIVIER

There is always a certain peace in being what one is, in being that completely.

UGO BETTI

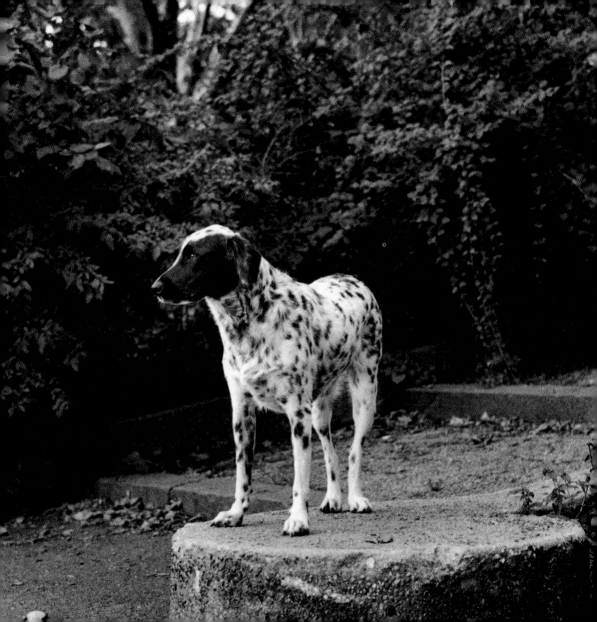

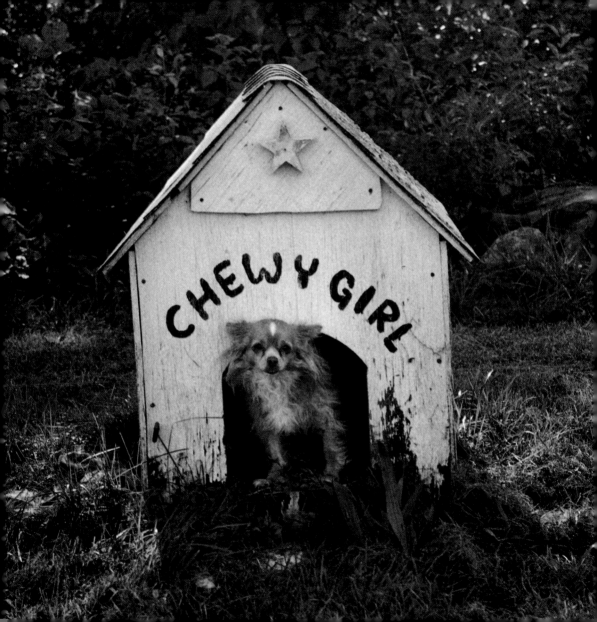

He is richest who is content with the least.

SOCRATES

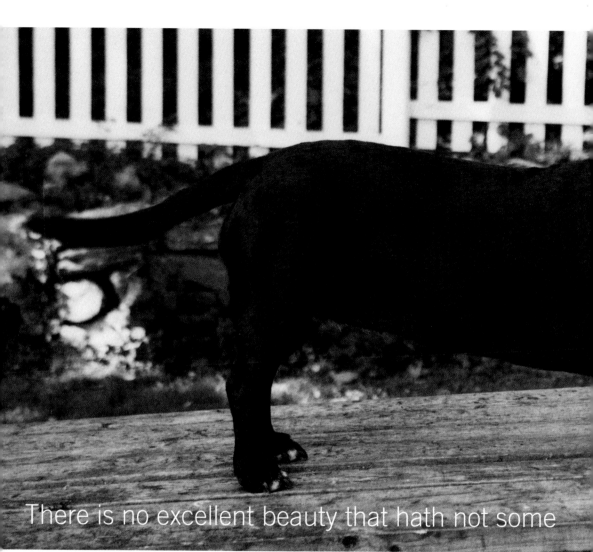

There is no excellent beauty that hath not some

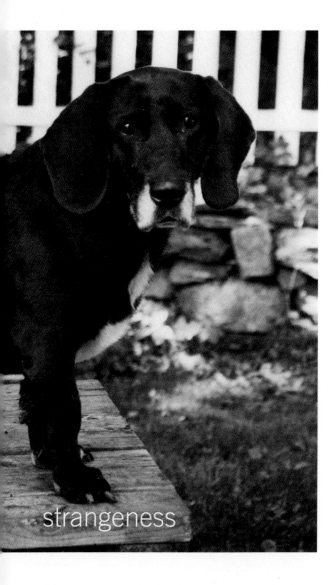

strangeness

in the proportions.

SIR FRANCIS BACON

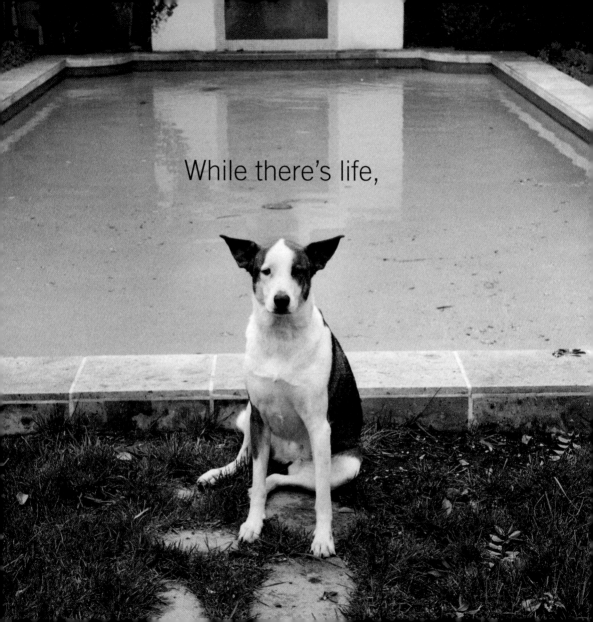

While there's life,

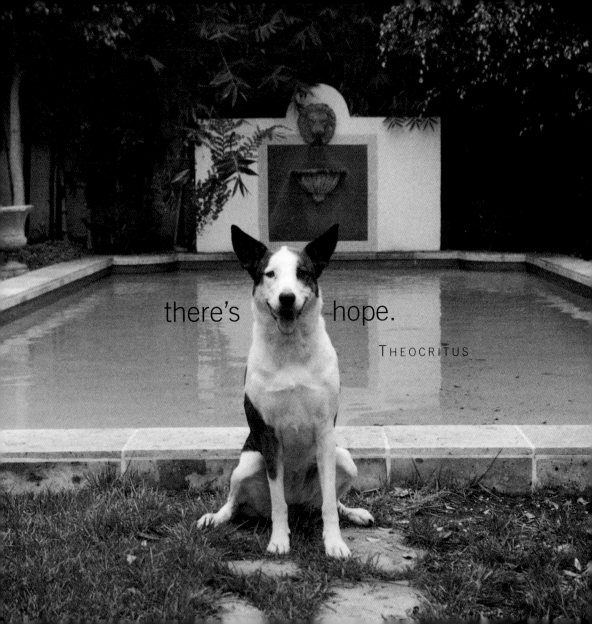

While there's life,
there's hope.

THEOCRITUS

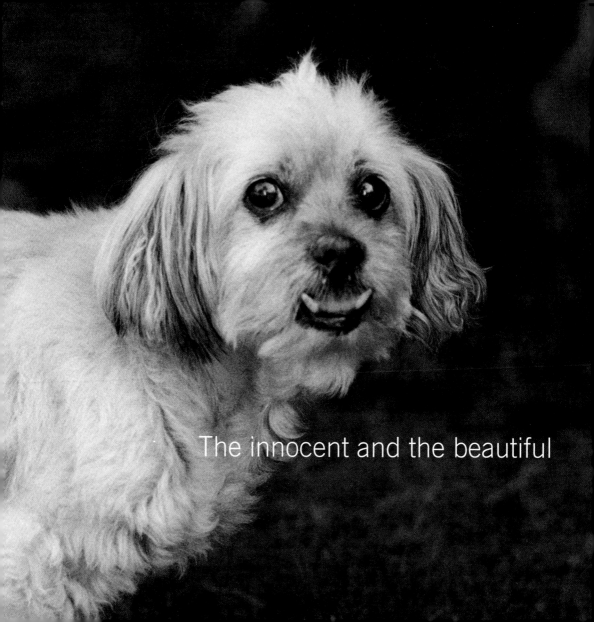

The innocent and the beautiful

have no enemies except time.

W. B. YEATS

6
1

The most called-upon prerequisite of a friend is

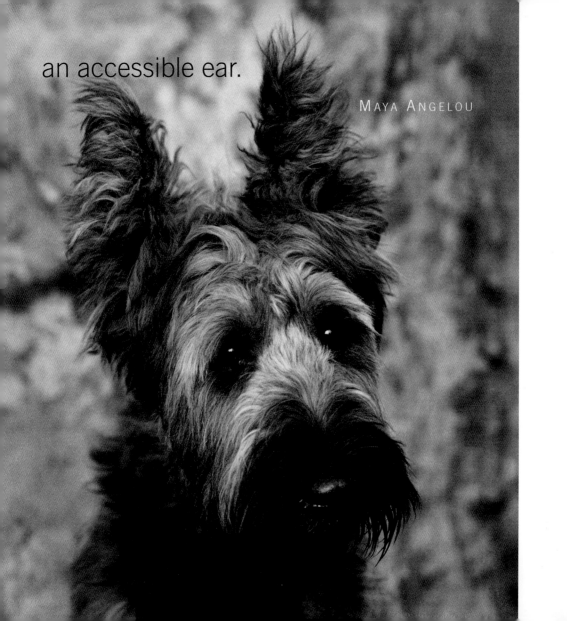

an accessible ear.

MAYA ANGELOU

I think if I weren't so beautiful
maybe I'd have more character.

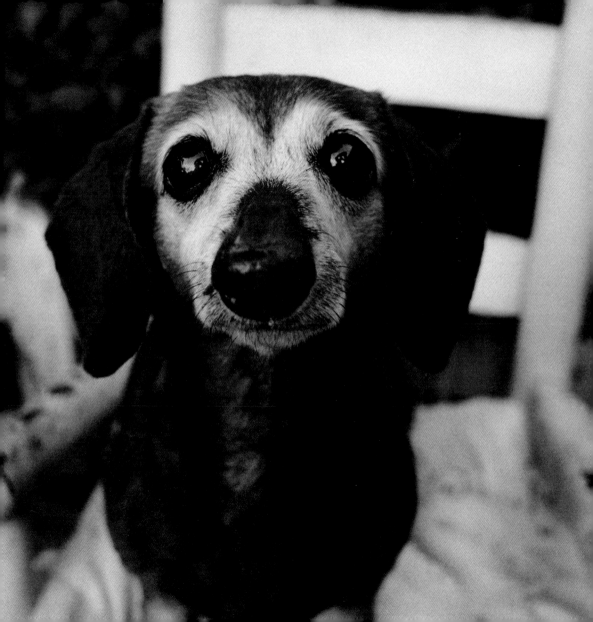

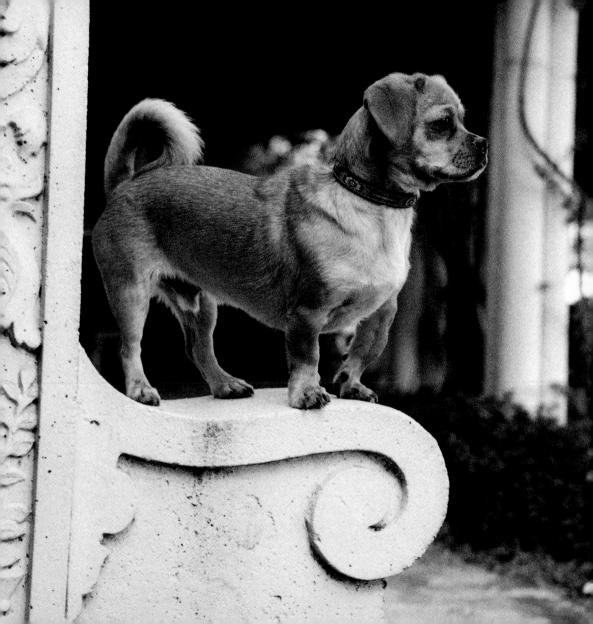

Heroes are created by popular demand somewhere out of the scantiest of materials.

GERALD W. JOHNSON

Why that dog is practically a Phi Beta Kappa. She can sit up and beg and she can give her paw— I don't say she will, but she can.

Dorothy Parker

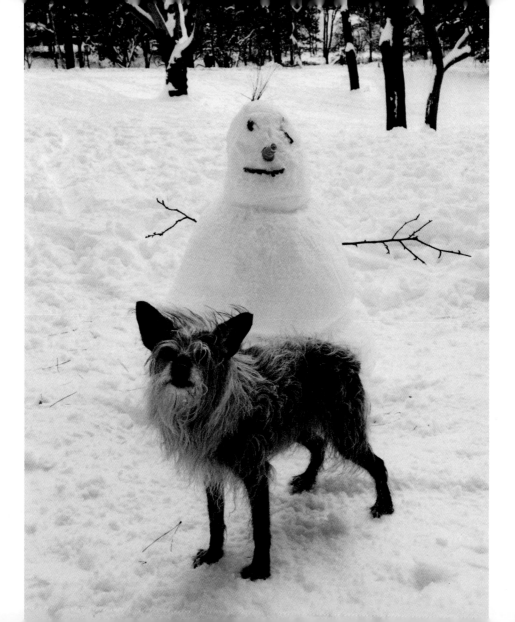

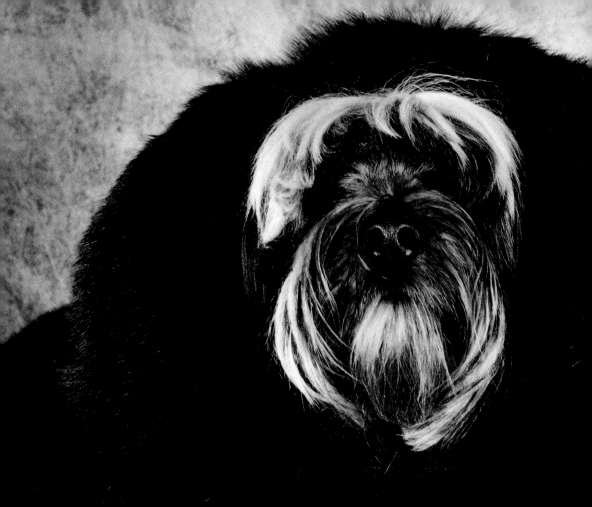

To love one's self is the beginning of

Two souls with but a single thought;
Two hearts that beat as one.

FRIEDRICH HALM

I sometimes look into the face of my dog Stan and see wistful sadness and existential angst, when all he is actually doing is slowly scanning the ceiling for flies.

MERRILL MARKOE

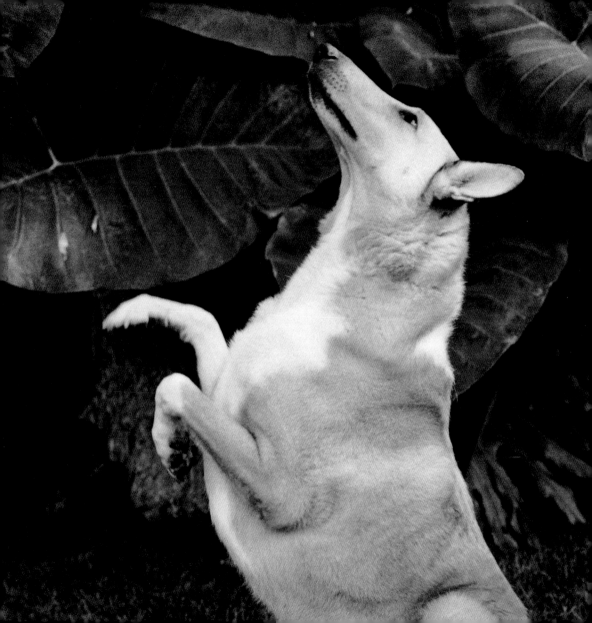

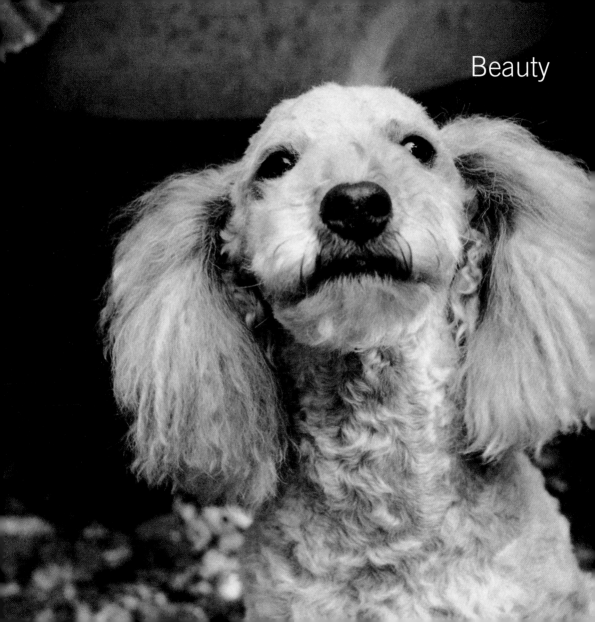

Beauty

is in the eye of the beholder.

MARGARET WOLFE HUNGERFORD

Dogs act exactly the way we would act

if we had no shame.

CYNTHIA HEIMEL

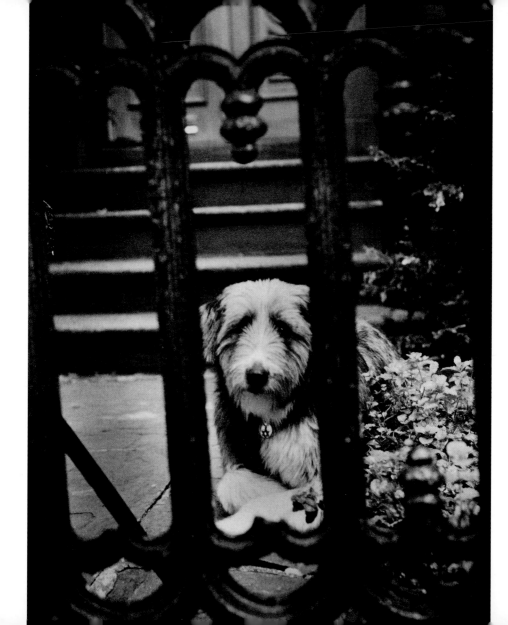

No one can make you feel inferior
without your consent.

ELEANOR ROOSEVELT

Style is knowing who you are, what you want

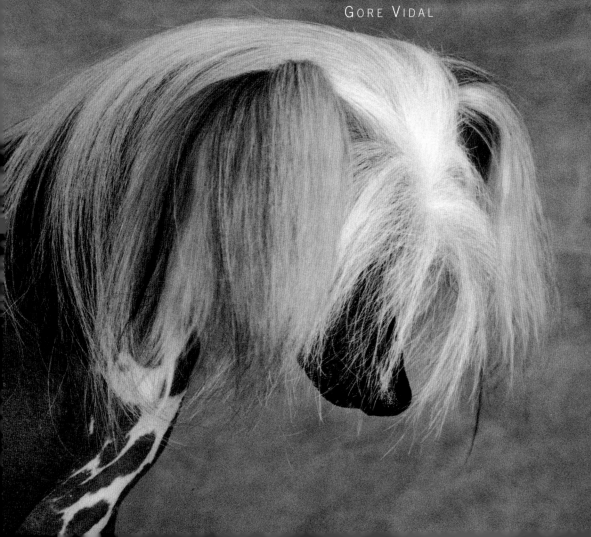

to say, and not giving a damn.

GORE VIDAL

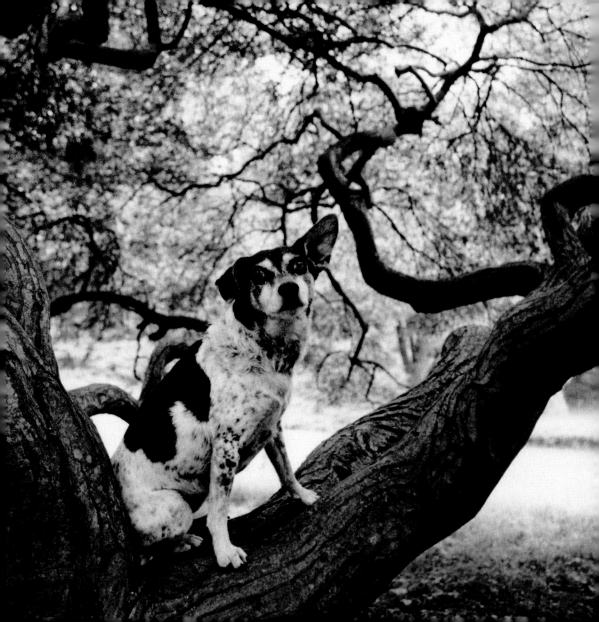

then something has been lost.

MARTHA GRAHAM

He who has "why" to live for
can bear almost any "how."

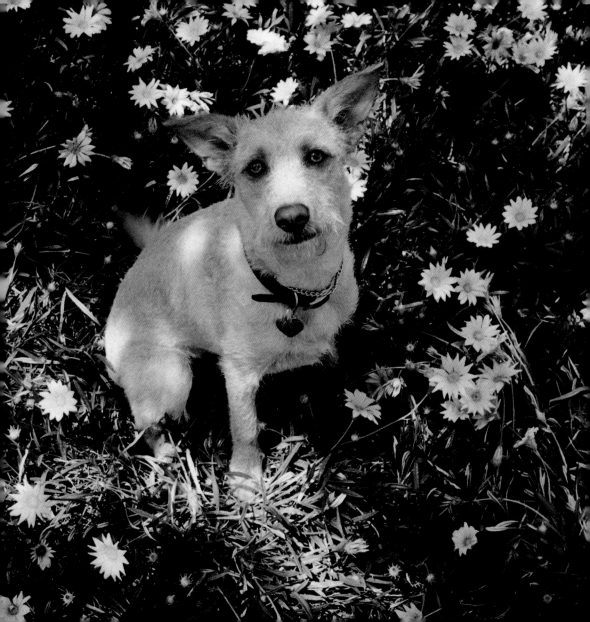

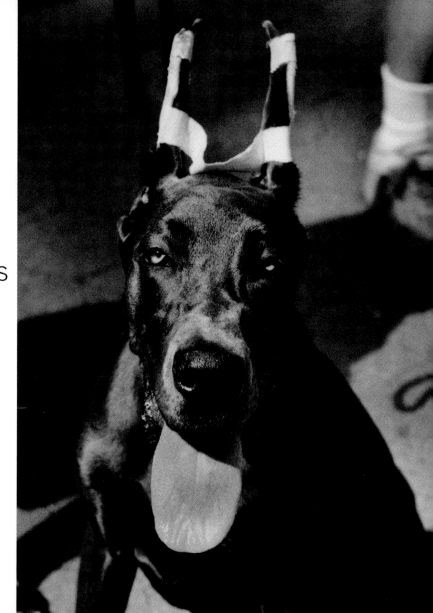

Eyes

are more accurate witnesses than ears.

HERACLITUS

What counts is not necessarily the size of the dog in the fight,

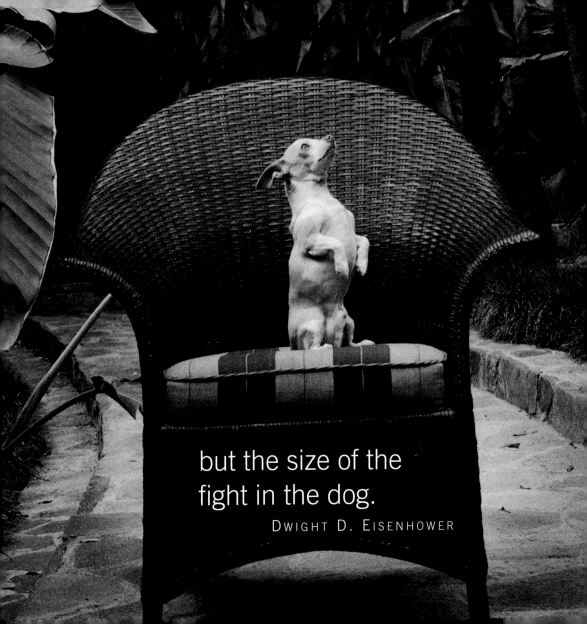

but the size of the
fight in the dog.

Dwight D. Eisenhower

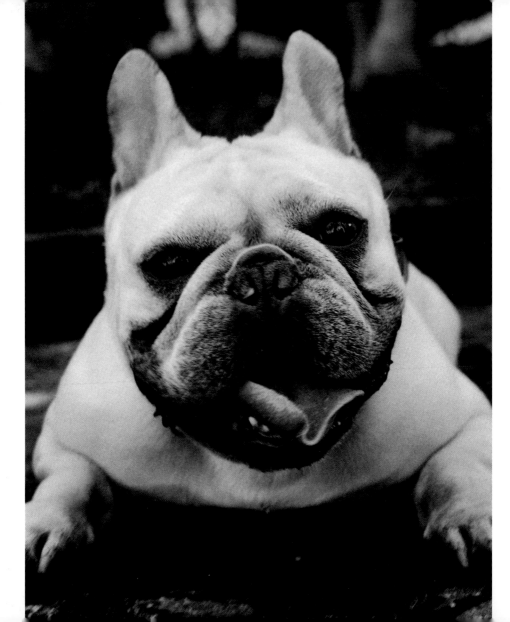

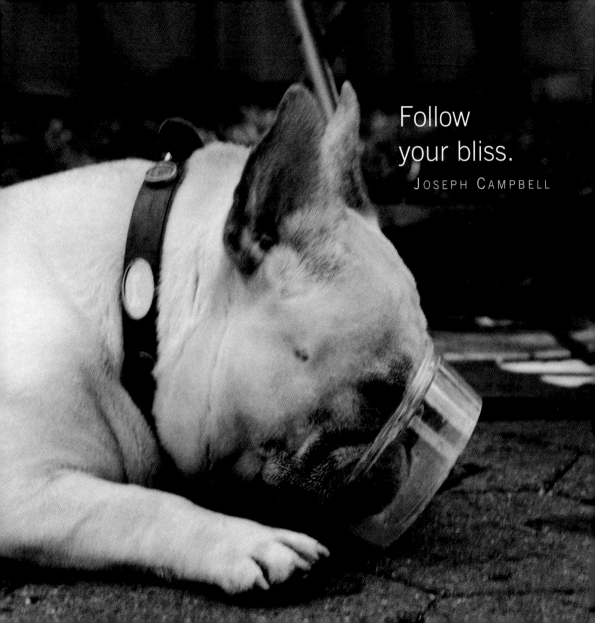

Follow
your bliss.

JOSEPH CAMPBELL

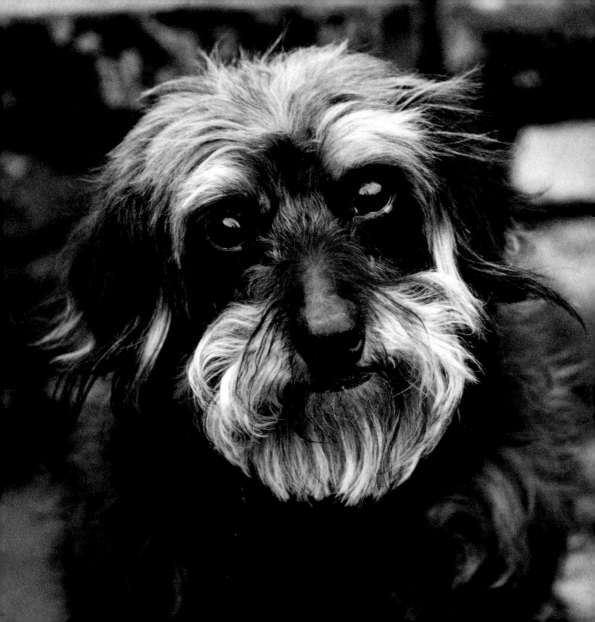

In youth we learn,
in age we understand.

MARIE VON EBNER-ESCHENBACH

No one can escape from
his individuality.

ARTHUR SCHOPENHAUER

But I dream things that never were;
and I say "Why not?"

GEORGE BERNARD SHAW

I am what I am, so take me as I am.

JOHANN VON GOETHE

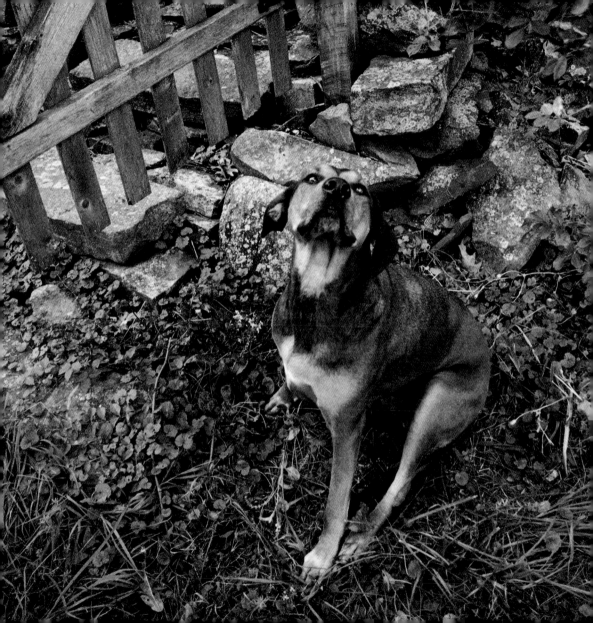

The world is not to
be put in order, the
world is in order.

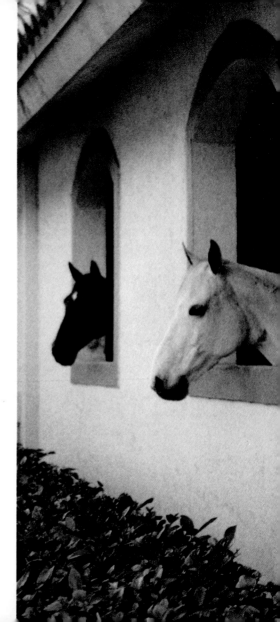

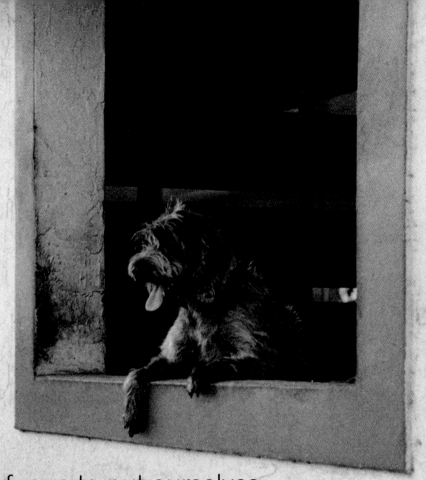

It is for us to put ourselves
in unison with this order.

HENRY MILLER

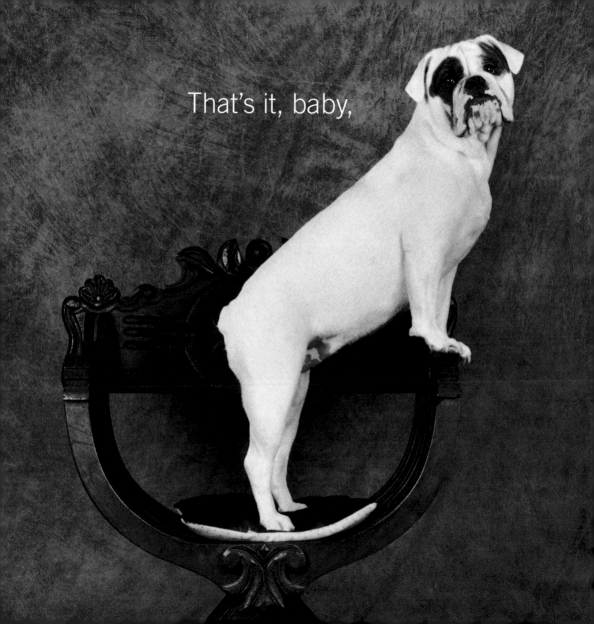

if you've got it, flaunt it.

MEL BROOKS

Nobody roots for Goliath.

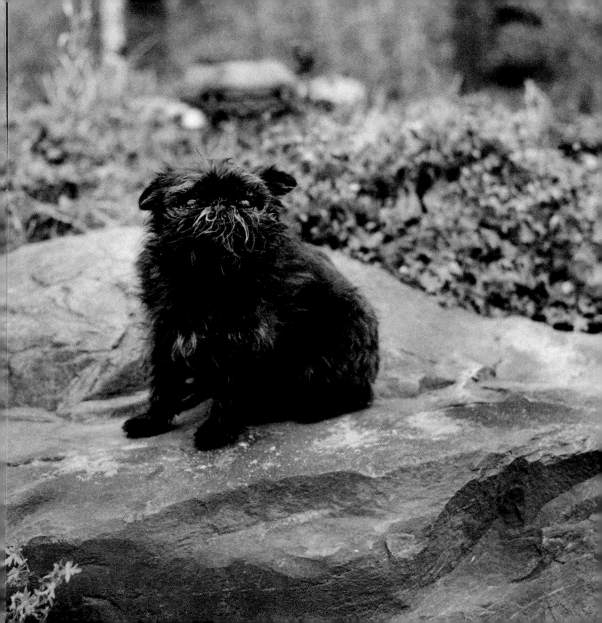

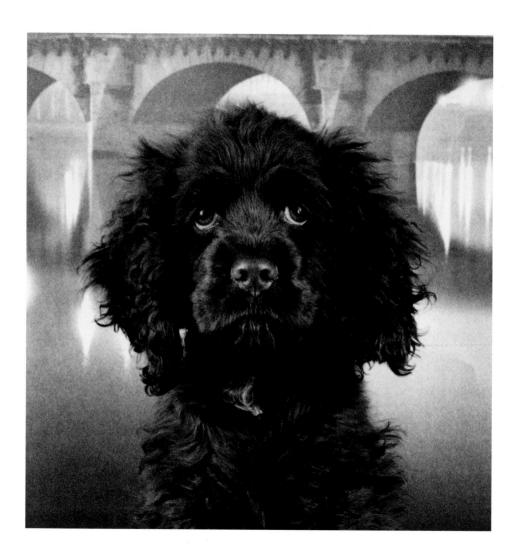

acknowledgments

Thank you to Nicole Duffy for her ability to focus with single-mindedness, whether tracking down that elusive detail or wrangling a wily underdog. To that ever winsome canine Charlie (left), whose expressions made my lensing look ever so artful, thus perking up his humans', Chris Pavone's and Madeline McIntosh's, ears and eyes to consider working on a project together. A heartfelt thank you to said Chris, who patiently waited for the right time to work together. I owe him not only my gratitude for his vital input as my editor without ever once barking at me or being intrusive, but for his tolerating my ability to be deadline-challenged as well.

Kudos to those at Clarkson Potter who made my scrap album of imagery into a beautiful, adorable book. Thus I tip my hat to: Marysarah Quinn, art director; Jane Treuhaft, designer; Leigh Ann Ambrosi, publicist; Trisha Howell, production editor; and Alison Forner, production manager.

To Patty and her technical geniuses at 68 Degrees who understand and get it right. My gratitude to Suzanne Barnett for keeping me good-humored when film had to be located. Thank you Ken, Marty, and Brittany for your skill and patience. To Spectra's Bob for his dedication to getting my prints back on time, and to Ed, who smoothes out many a bump in the road (or the celluloid, as it were).

To my mom not only for her devotion but for her proud display of my books on her piano. Well, here's one more for the eighty-eights! To my pop, who looks over me from above with pipe in mouth, smiling at "my son the author." To Donald Williams for being ever present with a hug. Praise and biscuits to my Labrador, Caleb, who has yet to make one of my books. I owe you big time, little fella.

And a chorus of howls of praise to all those wonderful soulful doggies who tickled my fancy, honoring me with the pleasure of capturing them in all of their canine splendor.

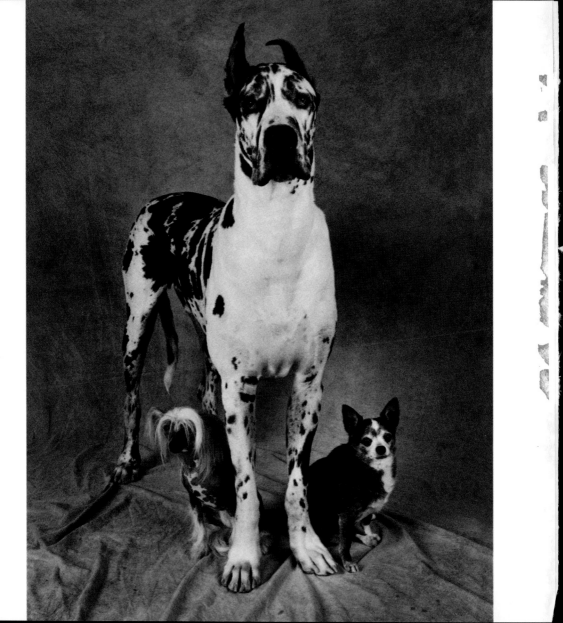

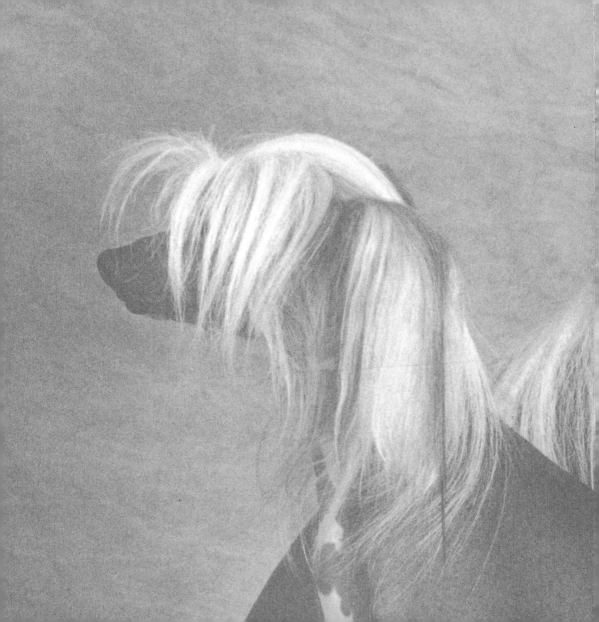